The award-winning pictures gathered in this diary have been drawn from the archives of the Wildlife Photographer of the Year competition – the international showcase for the very best nature photography. The competition is owned by the Natural History Museum, London, which prides itself on revealing and championing the diversity of life on Earth.

Wildlife Photographer of the Year is one of the most popular of the Museum's exhibitions. Visitors come not only to see breathtaking imagery, but also to understand some of the threats faced by our planet's animals and plants. Understanding and finding ways of conserving the Earth's biodiversity are at the heart of the Museum's work. This exhibition is one way to share that mission with others, encouraging us to see the environment around us with new eyes.

The Natural History Museum looks after a world-class collection of over 80 million specimens. It is also a leading scientific research institution, with ground-breaking projects in more than 68 countries. About 350 scientists work at the Museum, researching the valuable collections to better understand life on Earth. Every year more than five million visitors, of all ages and levels of interest, are welcomed through the Museum's doors.

2022

JANUARY

wk	M	T	W	Th	F	S	S
52						1	2
1	3	4	5	6	7	8	9
2	10	11	12	13	14	15	16
3	17	18	19	20	21	22	23
4	24	25	26	27	28	29	30
5	31						

FEBRUARY

wk	M	T	W	Th	F	S	S
5		1	2	3	4	5	6
6	7	8	9	10	11	12	13
7	14	15	16	17	18	19	20
8	21	22	23	24	25	26	27
9	28						

MARCH

wk	M	T	W	Th	F	S	S
9		1	2	3	4	5	6
10	7	8	9	10	11	12	13
11	14	15	16	17	18	19	20
12	21	22	23	24	25	26	27
13	28	29	30	31			

APRIL

wk	M	T	W	Th	F	S	S
13					1	2	3
14	4	5	6	7	8	9	10
15	11	12	13	14	15	16	17
16	18	19	20	21	22	23	24
17	25	26	27	28	29	30	

MAY

wk	M	T	W	Th	F	S	S
17							1
18	2	3	4	5	6	7	8
19	9	10	11	12	13	14	15
20	16	17	18	19	20	21	22
21	23	24	25	26	27	28	29
22	30	31					

JUNE

wk	M	T	W	Th	F	S	S
22			1	2	3	4	5
23	6	7	8	9	10	11	12
24	13	14	15	16	17	18	19
25	20	21	22	23	24	25	26
26	27	28	29	30			

JULY

wk	M	T	W	Th	F	S	S
26					1	2	3
27	4	5	6	7	8	9	10
28	11	12	13	14	15	16	17
29	18	19	20	21	22	23	24
30	25	26	27	28	29	30	31

AUGUST

wk	M	T	W	Th	F	S	S
31	1	2	3	4	5	6	7
32	8	9	10	11	12	13	14
33	15	16	17	18	19	20	21
34	22	23	24	25	26	27	28
35	29	30	31				

SEPTEMBER

wk	M	T	W	Th	F	S	S
35				1	2	3	4
36	5	6	7	8	9	10	11
37	12	13	14	15	16	17	18
38	19	20	21	22	23	24	25
39	26	27	28	29	30		

OCTOBER

wk	M	T	W	Th	F	S	S
39						1	2
40	3	4	5	6	7	8	9
41	10	11	12	13	14	15	16
42	17	18	19	20	21	22	23
43	24	25	26	27	28	29	30
44	31						

NOVEMBER

wk	M	T	W	Th	F	S	S
44		1	2	3	4	5	6
45	7	8	9	10	11	12	13
46	14	15	16	17	18	19	20
47	21	22	23	24	25	26	27
48	28	29	30				

DECEMBER

wk	M	T	W	Th	F	S	S
48				1	2	3	4
49	5	6	7	8	9	10	11
50	12	13	14	15	16	17	18
51	19	20	21	22	23	24	25
52	26	27	28	29	30	31	

2023

JANUARY

wk	M	T	W	Th	F	S	S
52							1
1	2	3	4	5	6	7	8
2	9	10	11	12	13	14	15
3	16	17	18	19	20	21	22
4	23	24	25	26	27	28	29
5	30	31					

FEBRUARY

wk	M	T	W	Th	F	S	S
5			1	2	3	4	5
6	6	7	8	9	10	11	12
7	13	14	15	16	17	18	19
8	20	21	22	23	24	25	26
9	27	28					

MARCH

wk	M	T	W	Th	F	S	S
9			1	2	3	4	5
10	6	7	8	9	10	11	12
11	13	14	15	16	17	18	19
12	20	21	22	23	24	25	26
13	27	28	29	30	31		

APRIL

wk	M	T	W	Th	F	S	S
13						1	2
14	3	4	5	6	7	8	9
15	10	11	12	13	14	15	16
16	17	18	19	20	21	22	23
17	24	25	26	27	28	29	30

MAY

wk	M	T	W	Th	F	S	S
18	1	2	3	4	5	6	7
19	8	9	10	11	12	13	14
20	15	16	17	18	19	20	21
21	22	23	24	25	26	27	28
22	29	30	31				

JUNE

wk	M	T	W	Th	F	S	S
22				1	2	3	4
23	5	6	7	8	9	10	11
24	12	13	14	15	16	17	18
25	19	20	21	22	23	24	25
26	26	27	28	29	30		

JULY

wk	M	T	W	Th	F	S	S
26						1	2
27	3	4	5	6	7	8	9
28	10	11	12	13	14	15	16
29	17	18	19	20	21	22	23
30	24	25	26	27	28	29	30
31	31						

AUGUST

wk	M	T	W	Th	F	S	S
31		1	2	3	4	5	6
32	7	8	9	10	11	12	13
33	14	15	16	17	18	19	20
34	21	22	23	24	25	26	27
35	28	29	30	31			

SEPTEMBER

wk	M	T	W	Th	F	S	S
35					1	2	3
36	4	5	6	7	8	9	10
37	11	12	13	14	15	16	17
38	18	19	20	21	22	23	24
39	25	26	27	28	29	30	

OCTOBER

wk	M	T	W	Th	F	S	S
39							1
40	2	3	4	5	6	7	8
41	9	10	11	12	13	14	15
42	16	17	18	19	20	21	22
43	23	24	25	26	27	28	29
44	30	31					

NOVEMBER

wk	M	T	W	Th	F	S	S
44			1	2	3	4	5
45	6	7	8	9	10	11	12
46	13	14	15	16	17	18	19
47	20	21	22	23	24	25	26
48	27	28	29	30			

DECEMBER

wk	M	T	W	Th	F	S	S
48					1	2	3
49	4	5	6	7	8	9	10
50	11	12	13	14	15	16	17
51	18	19	20	21	22	23	24
52	25	26	27	28	29	30	31

27 Monday Christmas Day, holiday (Christian)

28 Tuesday Boxing Day, holiday (Christian)

29 Wednesday

30 Thursday

31 Friday New Year's Eve
 Hogmanay (Scotland)

1 Saturday New Year's Day | 2 Sunday

Curious encounter *by Cristobal Serrano*
Any close encounter with an animal in the vast wilderness of Antarctica
happens by chance, so Cristobal was thrilled by this spontaneous meeting
with a crabeater seal off Cuverville Island, Antarctic Peninsula. These
curious creatures are protected and, with few predators, thrive.

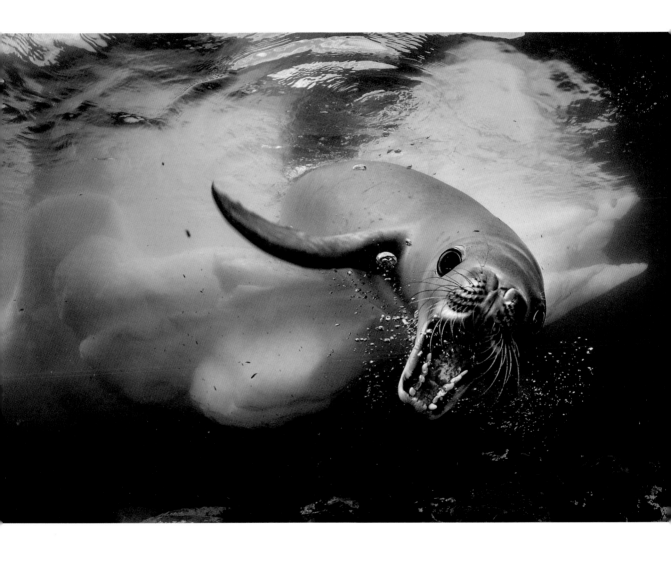

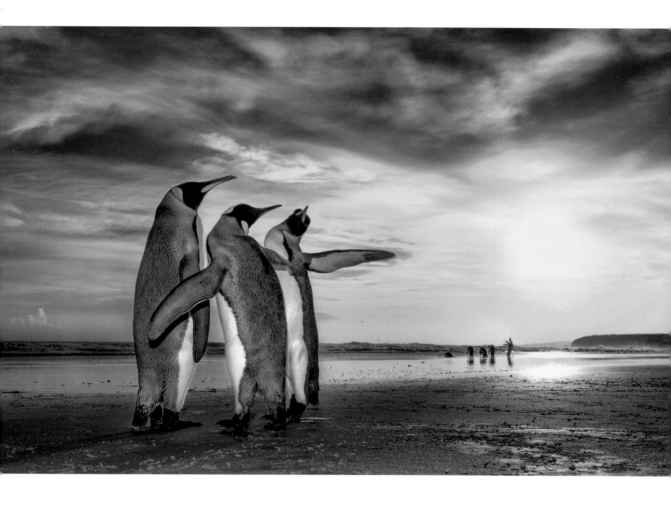

January

3 Monday

4 Tuesday

5 Wednesday

6 Thursday

Epiphany (Christian)

7 Friday

8 Saturday | 9 Sunday

Three kings *by Wim van den Heever*
Wim came across these king penguins on a beach in the Falkland Islands
just as the sun was rising. They were caught up in a fascinating mating
behaviour – the two males constantly moving around the female using
their flippers to fend the other off.

10 Monday

11 Tuesday

12 Wednesday

13 Thursday

14 Friday

15 Saturday

16 Sunday

The extraction *by Konstantin Shatenev*
Hundreds of Steller's sea eagles gather on the northeastern coast of
Hokkaido, Japan, during their winter migration from Russia. The eagles
search for food among the floating ice floes and along the sea coast.
Konstantin took this image from a boat, with the help of bait.

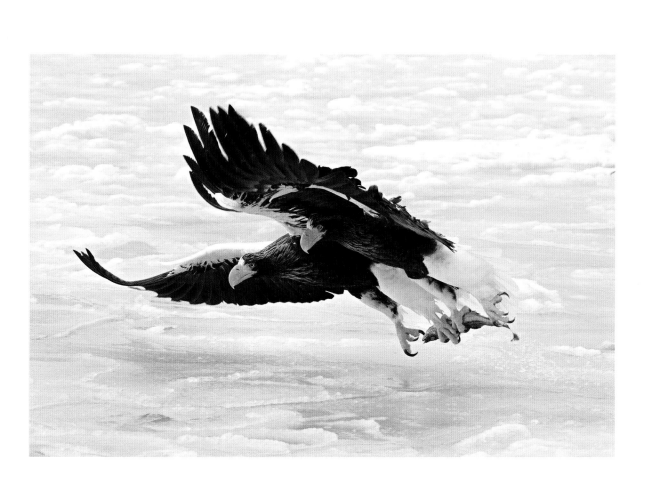

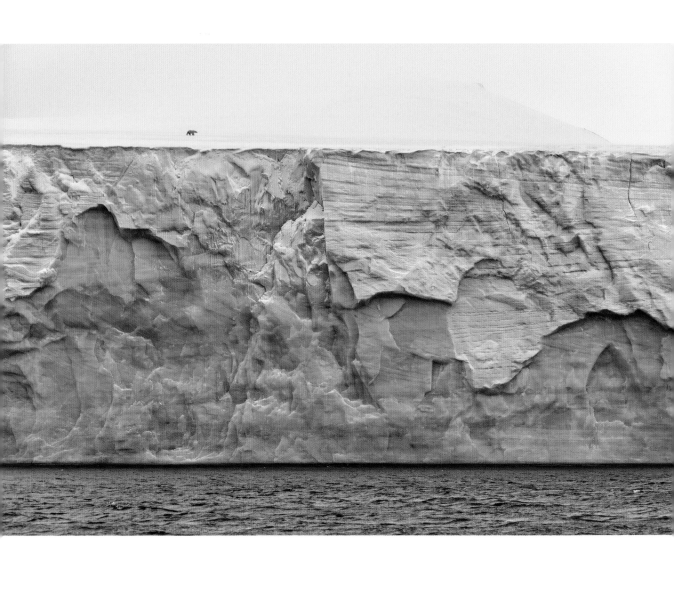

January

17 Monday Martin Luther King Day (USA)

18 Tuesday

19 Wednesday

20 Thursday

21 Friday

22 Saturday	23 Sunday

A bear on the edge *by Sergey Gorshkov*
A polar bear cuts a lonely figure as it walks near the edge of the Champ
Island glacier in Franz Josef Land, high in the Russian Arctic. The bear is
surefooted on the glacial ice. Its non-retractable claws dig in like ice-picks,
while small bumps on the soles of its feet keep the bear from slipping.

January

24 Monday

25 Tuesday Burns Night (Scotland)

26 Wednesday Australia Day

27 Thursday

28 Friday

29 Saturday | 30 Sunday

Under the snow *by Audren Morel*
Unafraid of the snowy blizzard, this squirrel came to visit Audren as he
was taking photographs of birds in the small villlage of Jura in Les Fourgs,
France. Impressed by the squirrel's endurance and character, he made it
the subject of the shoot.

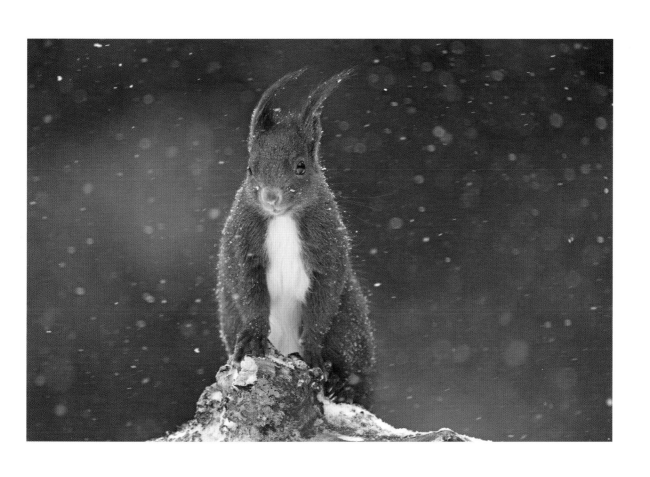

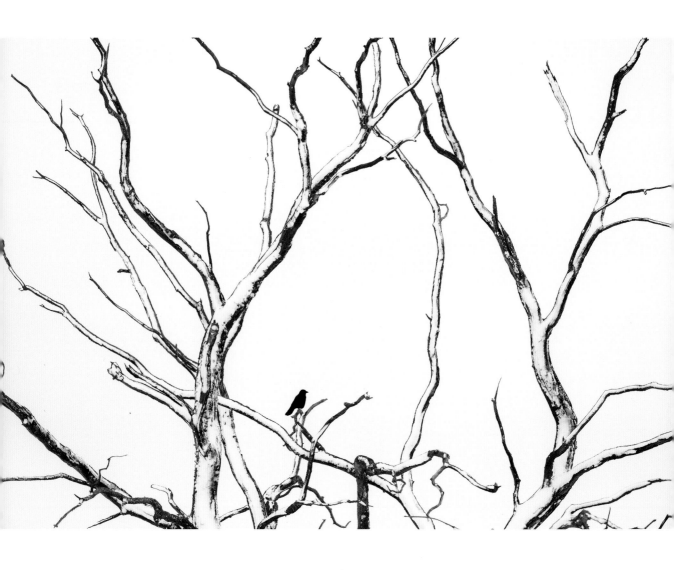

31 Monday

1 Tuesday Chinese New Year (Year of the Tiger)

2 Wednesday

3 Thursday

4 Friday

5 Saturday

6 Sunday

Winter lattice *by Michel d'Oultremont*
Out looking for foxes in the snow around Lescheret, Belgium, Michel
was drawn to the graphic design of this dead tree and its snow-dusted
branches against the white sky. A solitary carrion crow alighted on one of
the lower limbs, so he framed it centrally, to give maximum impact.

February

7 Monday

8 Tuesday

9 Wednesday

10 Thursday

11 Friday

12 Saturday

13 Sunday

Night snack *by Audun Rikardsen*
Large numbers of herring were overwintering in the fjords in Kaldfjord, in
northern Norway, attracting whales and fishing boats. Lit by a light from a
nearby fishing vessel, Audun seized his chance to document a killer whale,
amid gleaming herring scales, feeding in the harsh cold and clear ocean.

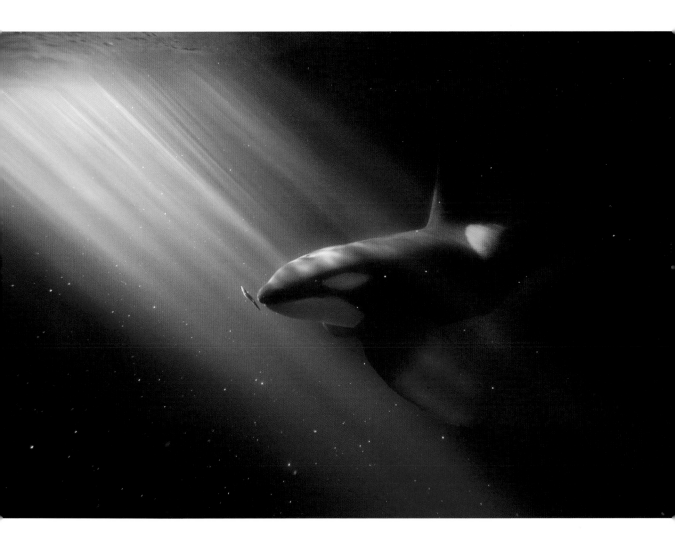

February

14 Monday

15 Tuesday

16 Wednesday

17 Thursday

18 Friday

19 Saturday

20 Sunday

Silent skirmish *by Michel d'Oultremont*
In a winter white-out, in Cambrai, northern France, two short-eared owls
squabble over a mouse. As the owls showed off their aerial agility, Michel
focused on their piercing yellow eyes. He got his picture, but the contest
had no victor – 'The mouse fell and escaped alive.'

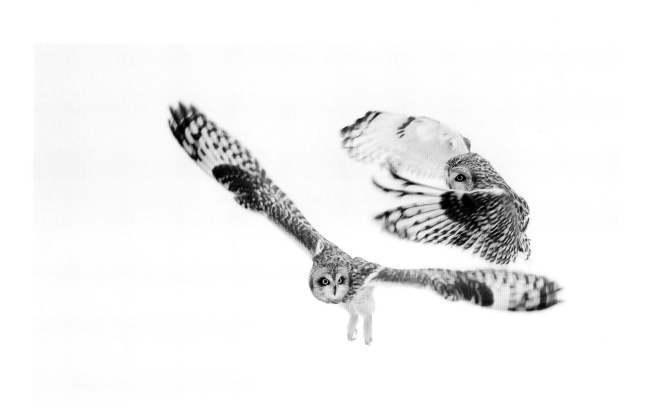

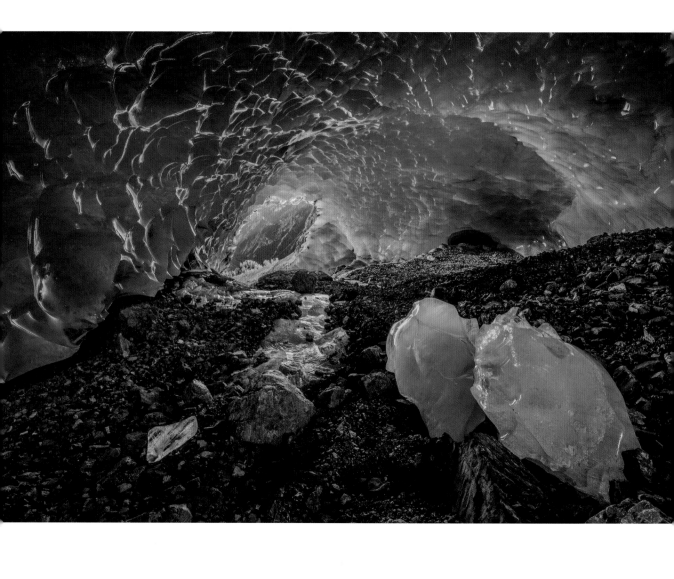

February

21 Monday

22 Tuesday

23 Wednesday

24 Thursday

25 Friday

26 Saturday

27 Sunday

Ice-cave blues *by Georg Kantioler*
Georg was immersed in a dripping cool blue world that had formed
beneath the creaking glacier in northern Italy's Stelvio National Park. He
caught the sunlight streaming through the main opening, illuminating
the distant larch trees and alpine scenery.

28 Monday

1 Tuesday

Shrove Tuesday, Pancake Day (Christian)
St David's Day (Wales)

2 Wednesday

Ash Wednesday (Christian)

3 Thursday

4 Friday

5 Saturday

6 Sunday

Queen's Elizabeth II's Platinum Jubilee
70-year reign

The ice pool *by Cristobal Serrano*
On a cloudy day – perfect for revealing textures of ice – Cristobal scoured
the Errera Channel on the west coast of the Antarctic Peninsula. Selecting
an iceberg that looked promising, he launched his low-noise drone. It
revealed a shallow heart-shaped ice pool and bathing crabeater seals.

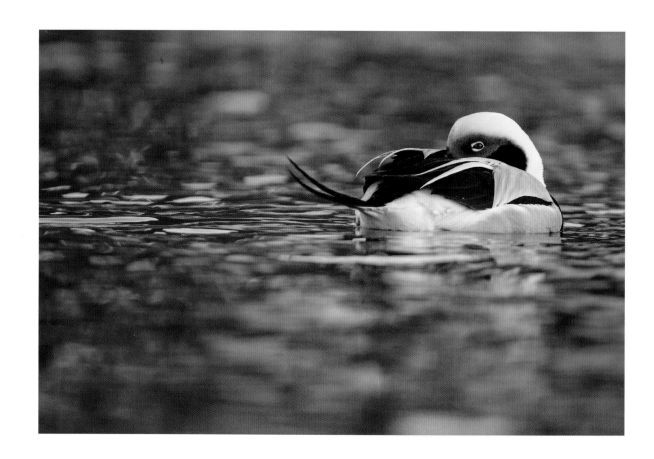

March

7 Monday

8 Tuesday

9 Wednesday

10 Thursday

11 Friday

12 Saturday

13 Sunday

Duck of dreams *by Carlos Perez Naval*
To photograph the long-tailed ducks on the northern coast of the Barents
Sea, Norway, Carlos booked a floating hide in the harbour and arrived
before sunrise. An overcast sky muted the subtle colours of the duck's
plumage, and lights from the village added a golden sparkle to the frame.

March

14 Monday

15 Tuesday

16 Wednesday

17 Thursday St Patrick's Day, holiday (Ireland)

18 Friday

19 Saturday

20 Sunday Spring Equinox

Simple beauty *by Theo Bosboom*
In a shallow tidal pool on the Isle of Lewis in Scotland's Outer Hebrides,
a colourful cluster of egg wrack and bladder wrack contrast against white
sand. Theo used a polarizing filter to avoid reflections and to reveal 'the
simple beauty of structures and patterns created by nature itself'.

21 Monday

22 Tuesday

23 Wednesday

24 Thursday

25 Friday

26 Saturday

27 Sunday

Mothering Sunday
British Summertime begins,
clocks go forward

Meadow song *by Fred Zacek*
Fred visited a secluded meadow close to his home in Estonia over three
days, to photograph the migratory birds that had arrived to breed. On the
third evening, he spotted this yellow wagtail, perched on a delicate stem
of cow parsley, singing in the soft evening light.

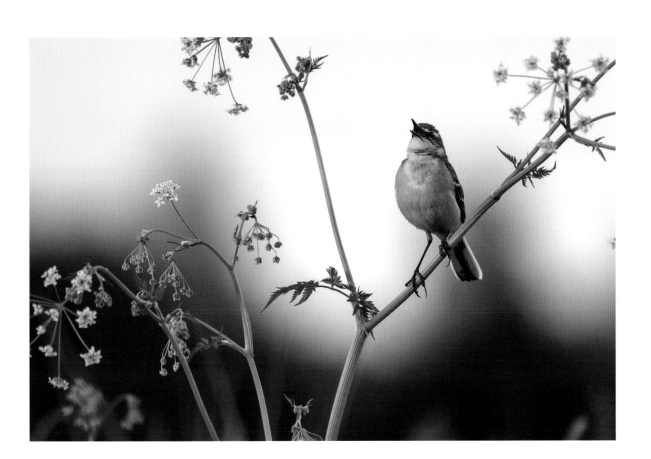

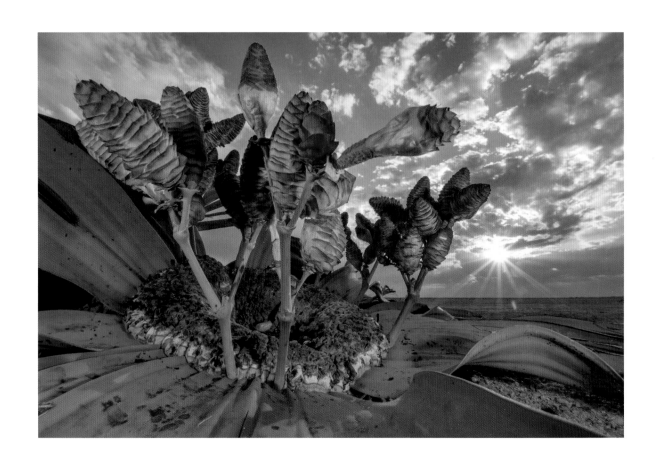

28 Monday

29 Tuesday

30 Wednesday

31 Thursday

1 Friday

April Fools' Day

2 Saturday

Ramadan begins (Islamic)
begins in the evening

3 Sunday

Desert relic *by Jen Guyton*
The cones of a female welwitschia reach for the skies over the Namib
Desert, proffering sweet nectar to insect pollinators. After trekking all day
over hot sand, Jen started to shoot as the sun was setting – catching the
plant's vibrant tones and architecture against the expansive landscape.

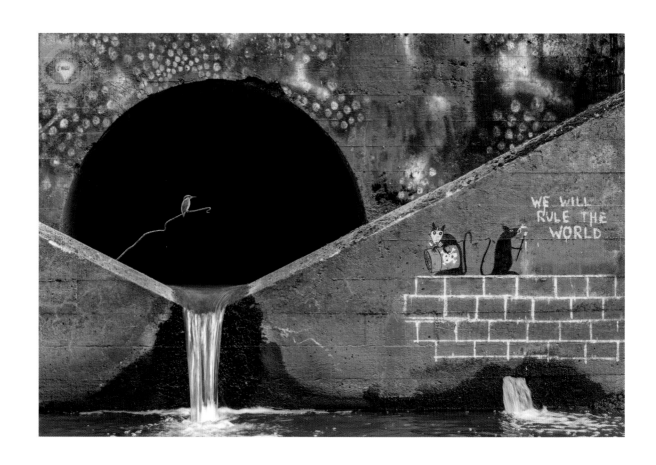

4 Monday

5 Tuesday

6 Wednesday

7 Thursday

8 Friday

9 Saturday

10 Sunday Palm Sunday (Christian)

City fisher *by Felix Heintzenberg*
This rusty metal rod at the opening of a sewage outlet pipe became a
favourite perch for a kingfisher pair. Seeing the photographic potential
of the urban stretch of the River Höje in southern Sweden, Felix captured
one of the kingfishers resting against the dark opening of the outlet.

11 Monday

12 Tuesday

13 Wednesday

14 Thursday

Maundy Thursday (Christian)

15 Friday

Good Friday, holiday (Christian)
First day of Passover (Jewish)
begins in the evening

16 Saturday

Last day of Passover (Jewish)
ends in the evening

17 Sunday

Easter Sunday (Christian)

Bear territory *by Marc Graf*
Slovenia's Notranjska Regional Park has one of the world's densest populations of brown bears. Photographing a bear with a camera trap, however, is not an easy task. It took Marc more than a year until finally this young bear, lit by the early morning sun, peered over the crest of a ridge.

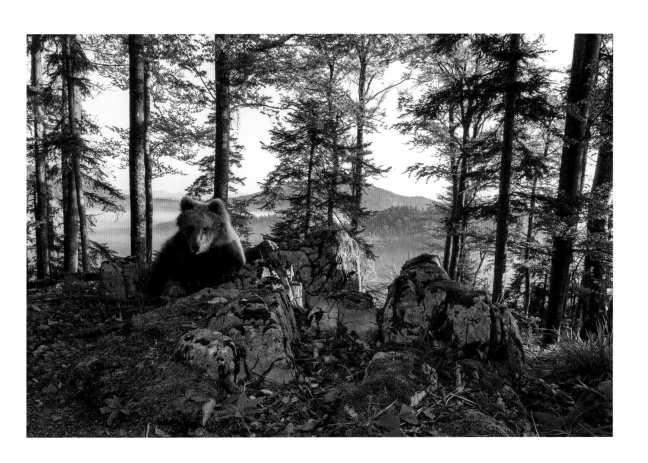

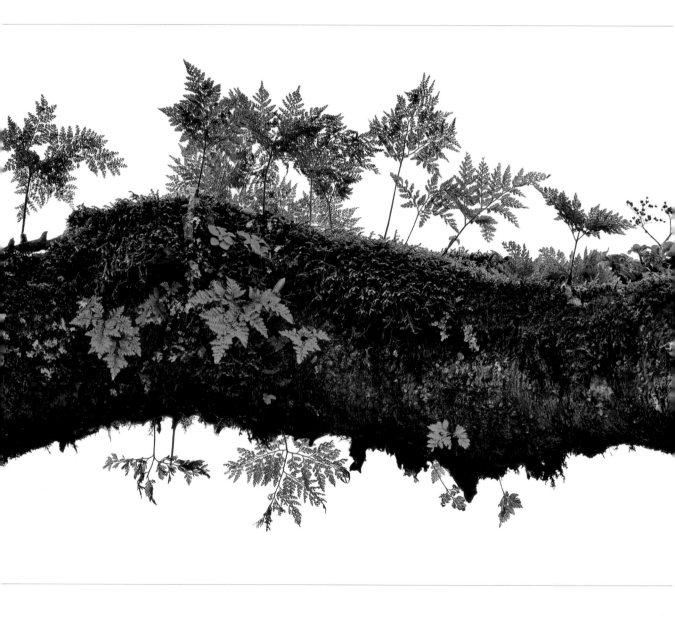

18 Monday Easter Monday, holiday (Christian)

19 Tuesday

20 Wednesday

21 Thursday Queen Elizabeth II's birthday

22 Friday

23 Saturday St George's Day (England) | **24 Sunday**

Forest on a tree *by Antonio Fernandez*
Huge branches hung eerily in the mist of Madeira's Fanal Forest,
Canary Islands, and among them was this one hanging from a tilo tree.
'With ferns growing all along it,' says Antonio, 'it was like a forest within
a forest'. He captured the branch isolated against a thick white fog.

25 Monday

26 Tuesday

27 Wednesday

28 Thursday

29 Friday

30 Saturday

1 Sunday Ramadan ends (Islamic)
ends in the evening

Sinuous moves *by Lorenzo Shoubridge*
A storm was brewing when Lorenzo spotted the adders' heads swaying in
a courtship dance above the sphagnum moss in the South Tyrol region of
the Italian Alps. Lying on the saturated ground, he levelled on the adders'
distinctive red eyes and isolated their entwined forms.

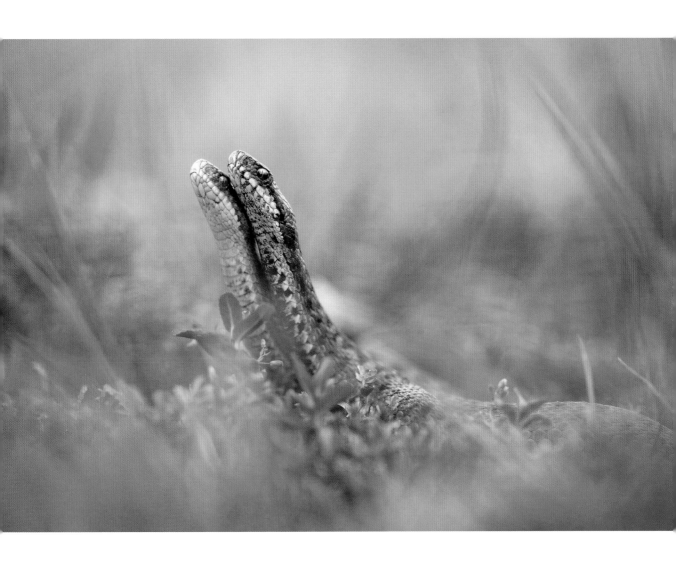

May

2 Monday

3 Tuesday

4 Wednesday

5 Thursday

6 Friday

7 Saturday

8 Sunday

Family portrait *by Connor Stefanison*
A great grey owl and her chicks sit in their nest in the broken top of a
Douglas fir tree in Kamloops, Canada. They looked towards Connor only
twice as he watched them during the nesting season from a tree hide
15 metres (50 feet) up.

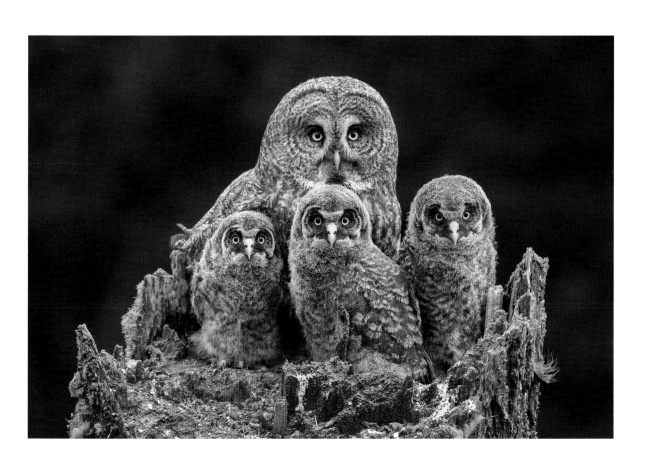

May

9 Monday

10 Tuesday

11 Wednesday

12 Thursday

13 Friday

14 Saturday | **15** Sunday

Painted waterfall *by Eduardo Blanco Mendizabal*
When the sun beams through a hole in the rock at the foot of the La Foradada waterfall, Catalonia, Spain, it creates a beautiful pool of light. The rays appear to paint the spray of the waterfall and create a truly magical picture.

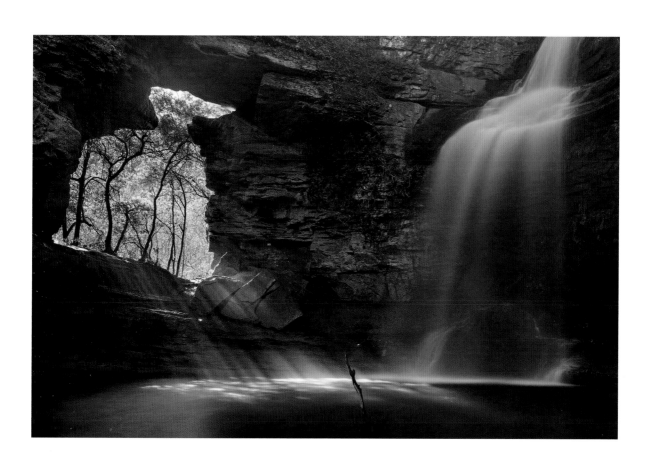

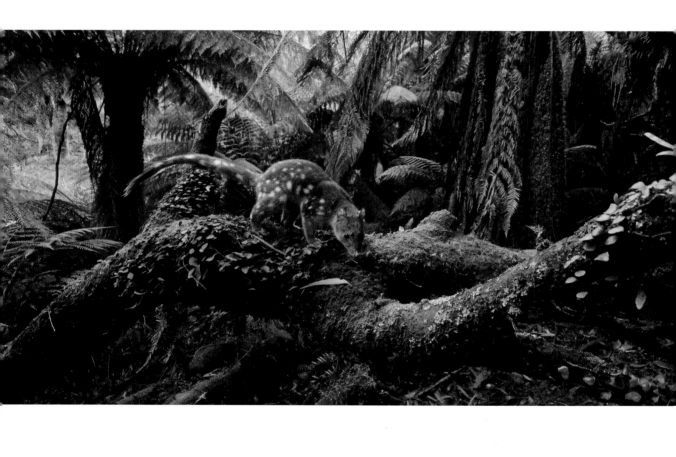

May

16 Monday

17 Tuesday

18 Wednesday

19 Thursday

20 Friday

21 Saturday

22 Sunday

Home of the quoll *by David Gallan*
Spotted-tailed quolls are rarely seen in the forests of southeastern New
South Wales, Australia, and it took David three years to locate them. He
set up a camera trap and, a month later, this female paused on the mossy
carpet of a fallen branch and inadvertently had her portrait taken.

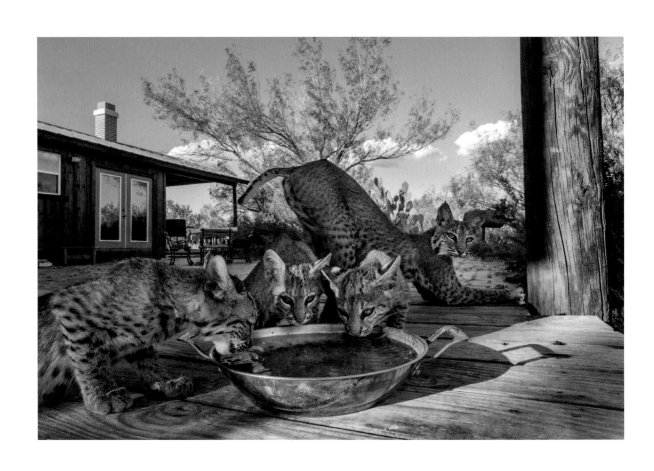

23 Monday

24 Tuesday

25 Wednesday

26 Thursday

Ascension Day (Christian)

27 Friday

28 Saturday	29 Sunday

Home on the range *by Karine Aigner*
Every afternoon, as the sun began to set, this bobcat led her kittens from
their den under the remote ranch house in southern Texas, onto the deck
for a drink, to relax and play. Over months Karine gained their trust and
got to know their characters, witnessing learning, love, fear and kinship.

30 Monday
<div align="right">Spring holiday (UK, Scotland)</div>

31 Tuesday

1 Wednesday

2 Thursday
<div align="right">May Day, holiday (observed)
Platinum Jubilee celebrations</div>

3 Friday
<div align="right">Holiday
Platinum Jubilee celebrations</div>

4 Saturday

5 Sunday
<div align="right">Whitsun (Christian)</div>

Red, silver and black *by Tin Man Lee*
Tin was fortunate enough to be told about a fox den in Washington State, North America, which was home to a family of red, black and silver foxes. These foxes display a great deal of pelt variation. After days of waiting for good weather he was finally rewarded with this touching moment.

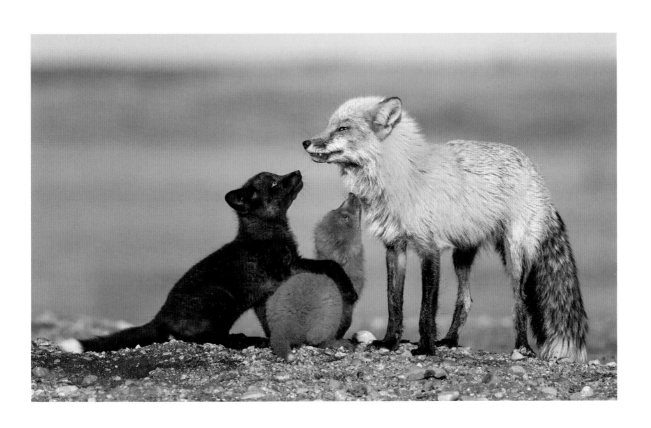

June

6 Monday June holiday (Republic of Ireland)

7 Tuesday

8 Wednesday

9 Thursday

10 Friday

11 Saturday	12 Sunday	Trinity Sunday (Christian)

Cool cat *by Isak Pretorius*
Isak positioned his vehicle on the opposite side of a waterhole in
Zambia's South Luangwa National Park. With perfect timing, a lioness
appeared through the tall, rainy-season grass and hunched down to drink.
Isak caught her gaze as she lapped, framed by the wall of lush green.

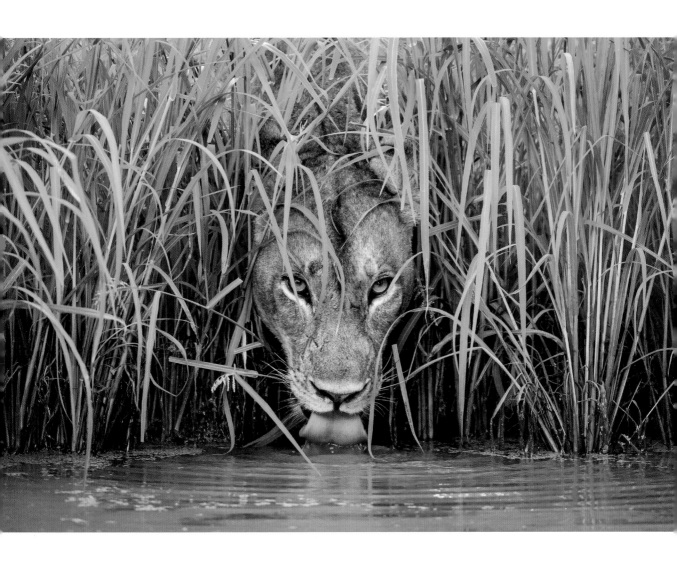

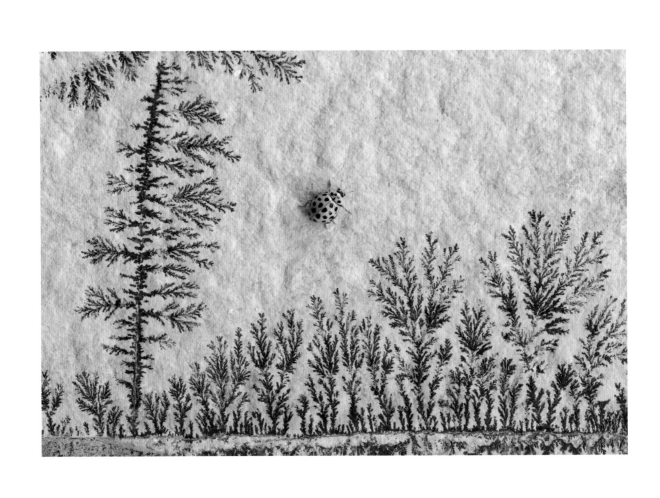

13 Monday

14 Tuesday

15 Wednesday

16 Thursday Corpus Christi (Christian)

17 Friday

18 Saturday | **19** Sunday Father's Day

Small world *by Carlos Perez Naval*
It was the tree-like crystal formations in the limestone wall in his home
town of Calamocha, in Aragon, Spain, that first caught Carlos' eye. He had
walked past it many times, then one day he noticed ladybirds crawling
between the miniature trees – and the idea for a picture was born.

June

20 Monday

21 Tuesday Summer Solstice

22 Wednesday

23 Thursday

24 Friday

25 Saturday

26 Sunday

Shy *by Pedro Carrillo*
The mesmerizing pattern of a beaded sand anemone, *Heteractis aurora*,
beautifully frames a juvenile Clarkii clownfish in Lembeh strait, Sulawesi,
Indonesia. Known as a 'nursery' anemone, it is often a temporary home for
young clownfish until they find a more suitable host anemone for adulthood.

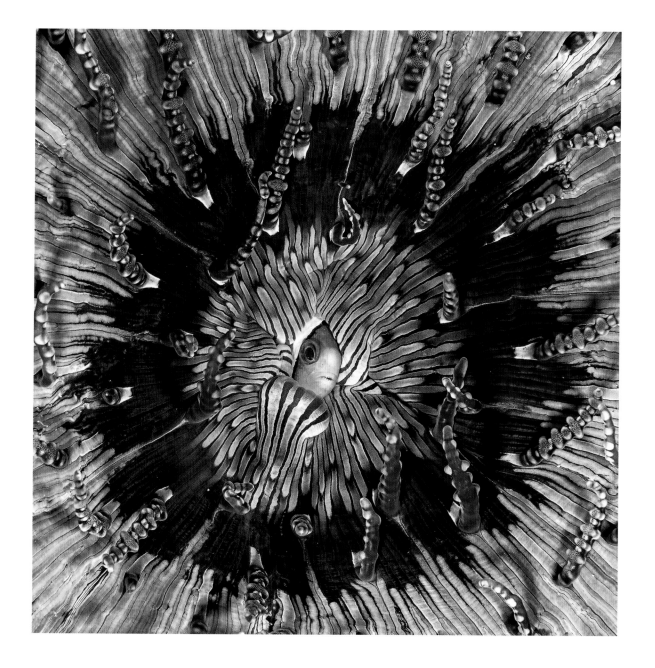

27 Monday

28 Tuesday

29 Wednesday

30 Thursday

1 Friday

Canada Day

2 Saturday	3 Sunday

A rock in a hard place *by Stefano Baglioni*
A diminutive living rock cactus breaks the surface of the parched plains
of Coahuila, northeast Mexico. Stefano caught the moment just before
sunset, when soft light enhanced the form and colours, the cracked
concrete earth testifying to the unstoppable life force of the little plant.

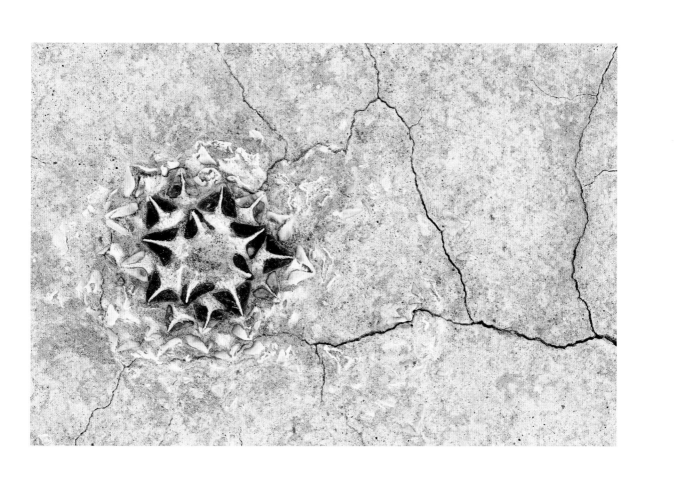

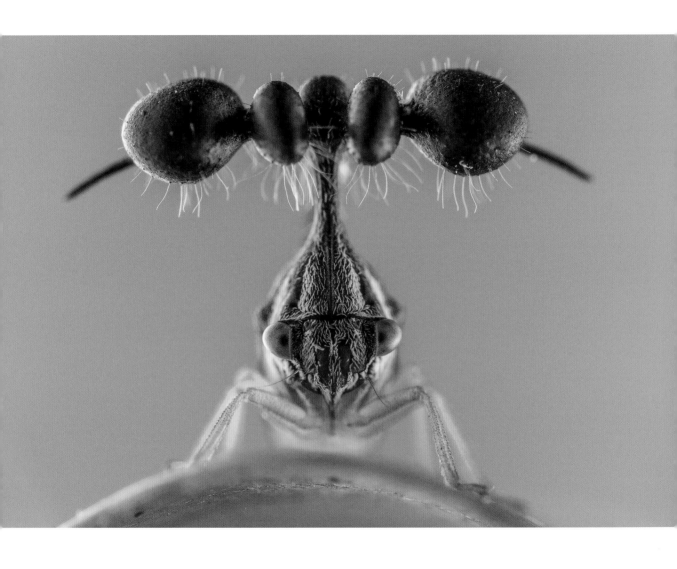

July

4 Monday

Independence Day (USA)

5 Tuesday

6 Wednesday

7 Thursday

8 Friday

9 Saturday

10 Sunday

Little big head *by Javier Aznar González de Rueda*
The outlandish appearance of the *Bocydium* treehopper belies its shy
nature. Javier found just two in the three months he spent looking for
them in the Amazon. Taking care not to scare the bug away, Javier
captured its eye-catching portrait head-on for maximum impact.

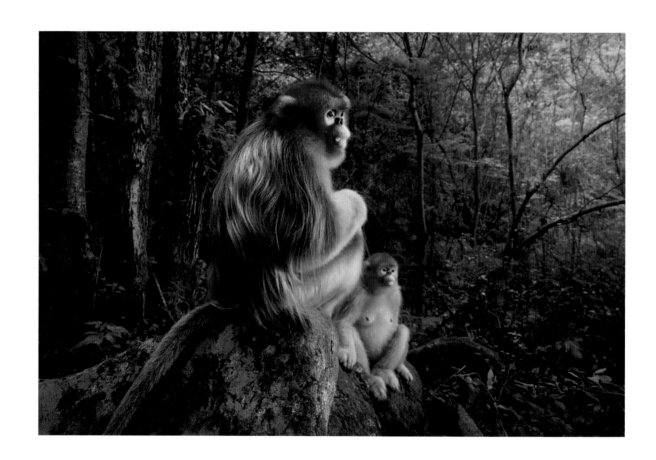

11 Monday

12 Tuesday

Battle of the Boyne,
holiday (Northern Ireland)

13 Wednesday

14 Thursday

15 Friday

St Swithin's Day (Christian)

16 Saturday

17 Sunday

The golden couple *by Marsel van Oosten*
Male and female Qinling golden snub-nosed monkeys rest briefly on
a stone seat in China's Qinling Mountains, the only place where these
endangered monkeys live. It took Marsel many days to capture their
golden locks and striking blue features against a perfect forest backdrop.

18 Monday

19 Tuesday

20 Wednesday

21 Thursday

22 Friday

23 Saturday	24 Sunday

Overview *by Cameron McGeorge*
From the island of Foa, Tonga, Cameron watched through binoculars for
whale blows out at sea. Having located a humpback mother, her young
calf and their male escort, he launched his drone. Cameron framed the
shot just as the playful calf and its mother breached the surface.

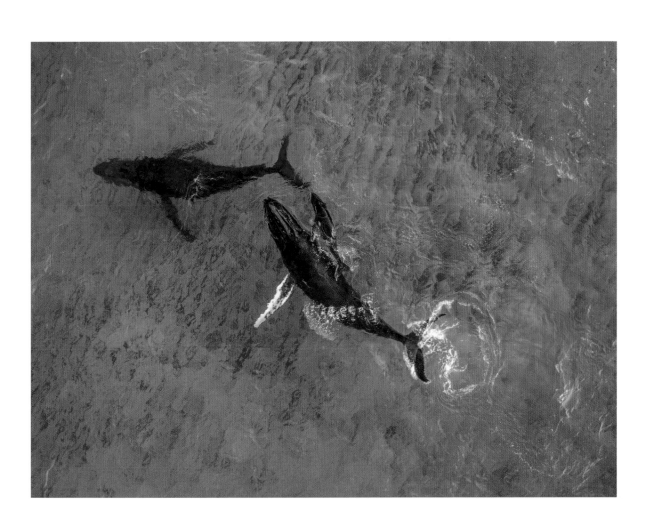

July

25 Monday

26 Tuesday

27 Wednesday

28 Thursday

29 Friday

30 Saturday

31 Sunday

Windsweep *by Orlando Fernandez Miranda*
Standing at the top of a high dune on Namibia's desert coastline, Orlando
focused on a sharp ridge of sand in front of him. Ensuring that the sweep
of wind-patterned dunes to his right remained in focus, he let the distant
fog-shrouded Atlantic coast fade into a mysterious horizon.

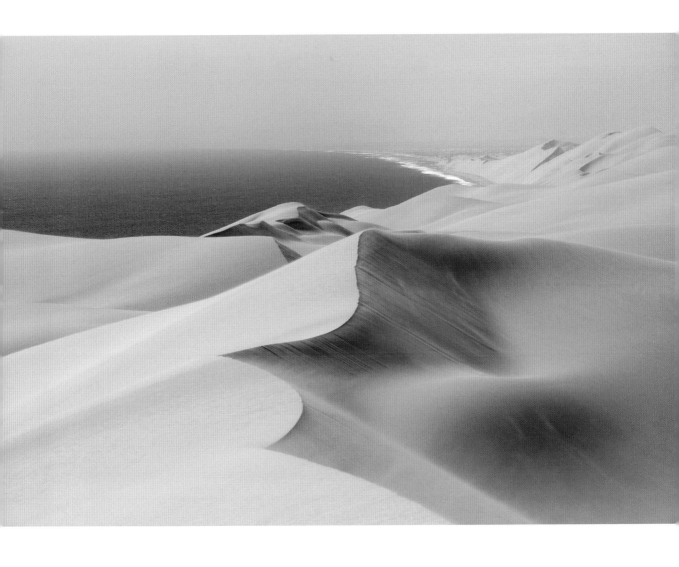

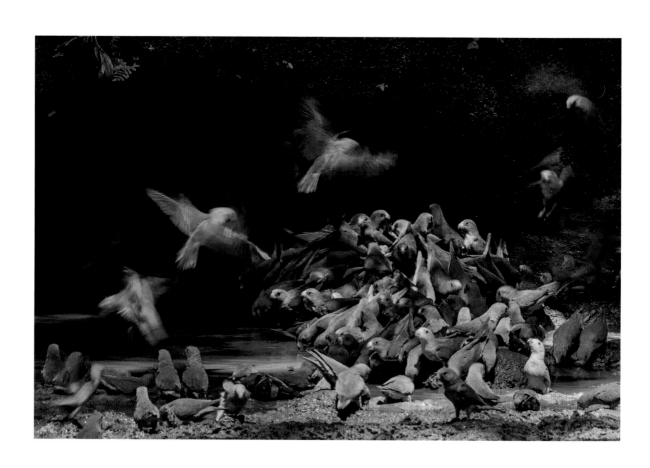

August

1 Monday Summer holiday (Scotland, Republic of Ireland)

2 Tuesday

3 Wednesday

4 Thursday

5 Friday

6 Saturday 7 Sunday

Colour, sound, action *by Liron Gertsman*
After waiting three mornings in a hide in Ecuador's Yasuní National Park, a
mass of cobalt-winged parakeets finally landed in a frenzy of colour and
deafening crescendo of squawks. They grabbed beakfuls of sodium-rich
muddy water and clay, a mineral lacking in their plant-based diets.

8 Monday

9 Tuesday

10 Wednesday

11 Thursday

12 Friday

13 Saturday

14 Sunday

Flight *by Sue Forbes*
One morning, northeast of D'Arros Island, the Seychelles, Sue awoke to find tranquil water and a single juvenile red-footed booby, circling her boat. Suddenly, a flying fish leapt out of the water and the booby gave chase. With quick reactions, she captured the fleeting moment.

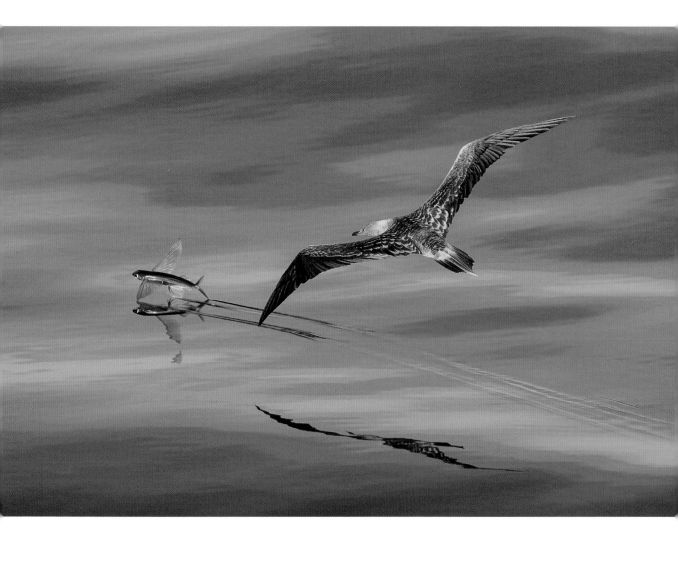

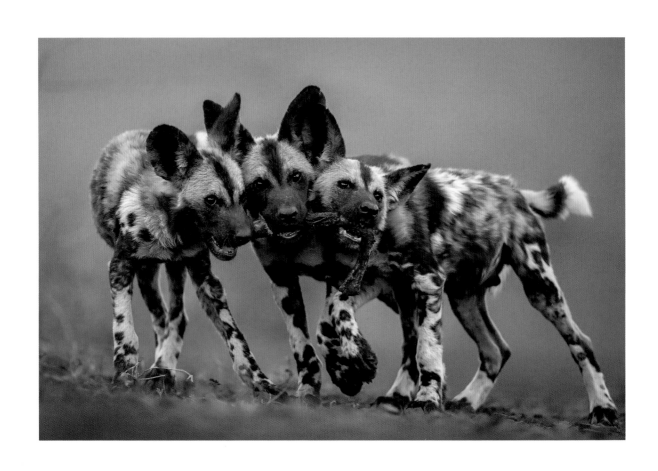

August

15 Monday

16 Tuesday

17 Wednesday

18 Thursday

19 Friday

20 Saturday

21 Sunday

One toy, three dogs *by Bence Mate*
While adult African wild dogs are merciless killers, their pups are extremely cute and play all day long. Bence photographed these brothers in Mkuze, South Africa – they all wanted to play with the leg of an impala and were trying to drag it in three different directions.

22 Monday

23 Tuesday

24 Wednesday

25 Thursday

26 Friday

27 Saturday

28 Sunday

Mister Whiskers *by Valter Bernardeschi*
On a bright summer's night Valter came across walruses feeding near an
island in the Norwegian archipelago off Svalbard. He slipped into the icy
water and a few curious walruses began swimming towards him. He was
able to take this intimate portrait of their distinctive whiskered faces.

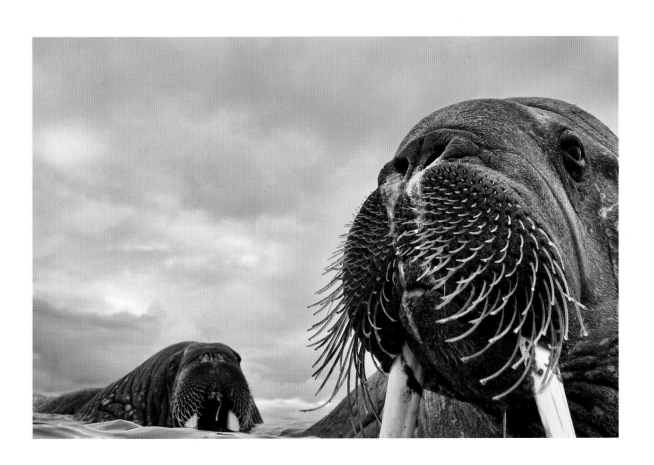

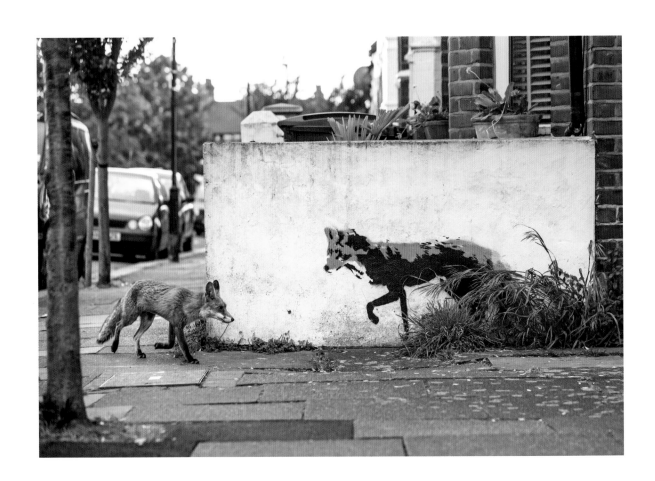

August – September

29 Monday

30 Tuesday

31 Wednesday

1 Thursday

2 Friday

3 Saturday

4 Sunday

Fox meets fox *by Matthew Maran*
Matthew has been photographing foxes close to his home in north
London for over four years, and ever since spotting this street art, had
dreamt of capturing this image. After countless hours, and many failed
attempts, his persistence paid off.

September

5 Monday

6 Tuesday

7 Wednesday

8 Thursday

9 Friday

10 Saturday

11 Sunday

The victor *by Adam Hakim Hogg*
When Adam first spotted the Titiwangsa horned tree lizard on the road near his home in the mountains of Pahang, Malaysia, it was in a furious life-and-death battle with a venomous Malaysian jewel centipede. The lizard conquered and then triumphantly stood over its prize.

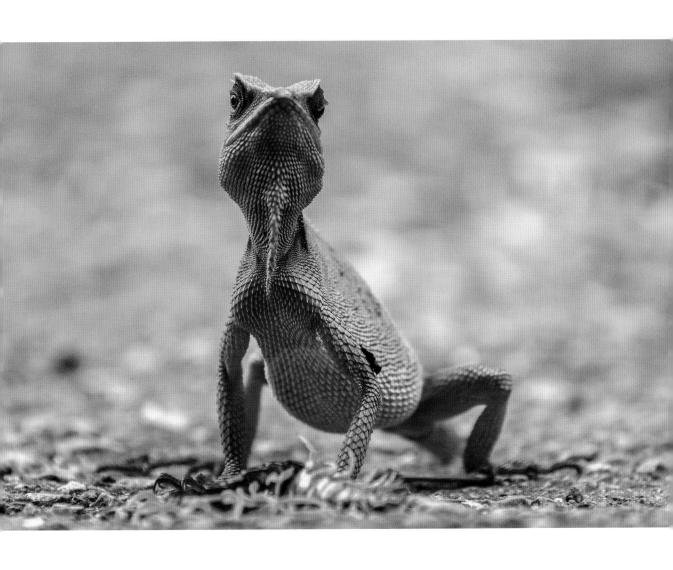

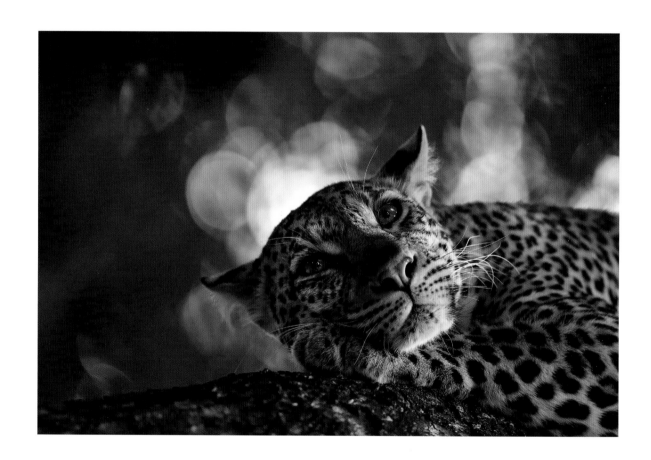

September

12 Monday

13 Tuesday

14 Wednesday

15 Thursday

16 Friday

17 Saturday

18 Sunday

Lounging leopard *by Skye Meaker*
This female leopard was dozing along a low branch of a nyala tree in
Botswana's Mashatu Game Reserve. Finally she opened her eyes, and the
overhead branches moved enough to let in a shaft of light that gave a
glint to her eyes, helping to create this memorable portrait.

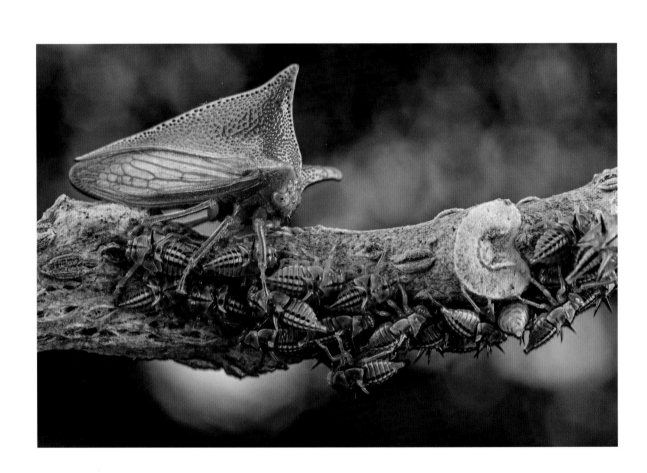

September

19 Monday

20 Tuesday

21 Wednesday

22 Thursday

23 Friday Autumn Equinox

24 Saturday

25 Sunday Rosh Hashanah, Jewish New Year
 begins in the evening

Mother defender *by Javier Aznar González de Rueda*
A large Alchisme treehopper stands over her family as the nymphs feed
on the stem of a nightshade plant in El Jardín de los Sueños reserve in
Ecuador. Unusally for treehoppers, this species is guarded by the devoted
mother who defends her brood until adulthood.

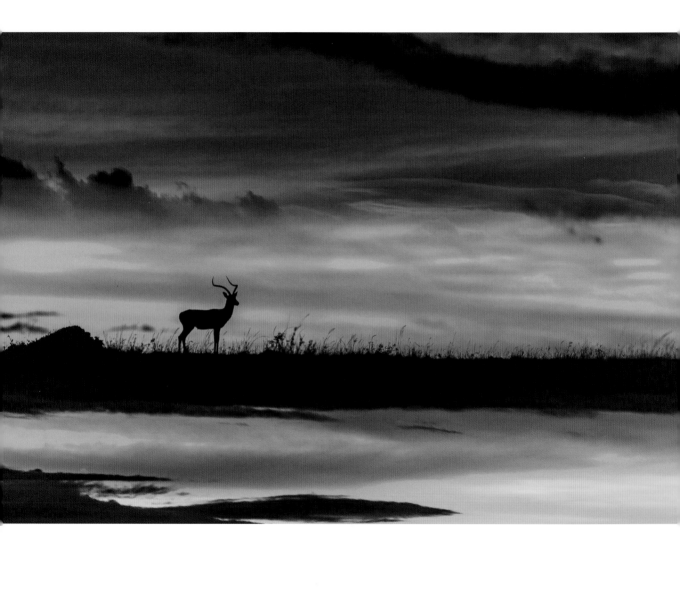

26 Monday

27 Tuesday

Rosh Hashanah, Jewish New Year
ends in the evening

28 Wednesday

29 Thursday

30 Friday

1 Saturday

2 Sunday

Reflective sunset *by Sri Ram Mohan Akshay Valluru*
Akshay spotted this lone male impala on the horizon as he returned
from a game drive in Kenya's Maasai Mara National Reserve. Drawn to
the statuesque silhouette of the creature, he asked the guide to stop
the vehicle just as the most glorious sunset appeared.

3 Monday

4 Tuesday

Yom Kippur (Jewish)
begins in the evening

5 Wednesday

Yom Kippur (Jewish)
ends in the evening

6 Thursday

7 Friday

8 Saturday

9 Sunday

Delta design *by Paul Mckenzie*
Flying over the Southern Ewaso Ng'iro River delta, on the border of Kenya
and Tanzania, Paul was mesmerized by the patterns of algae, spreading
through the river sediment. Framing his shot through the plane's open
door, he battled turbulence to capture nature's composition.

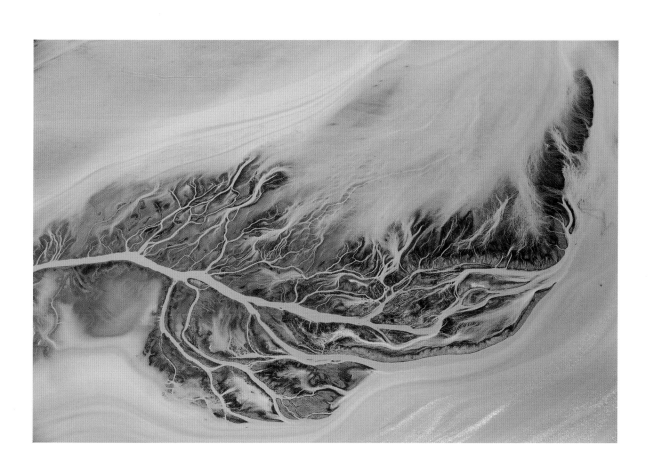

October

10 Monday

11 Tuesday

12 Wednesday

13 Thursday

14 Friday

15 Saturday

16 Sunday

Tigerland *by Emmanuel Rondeau*
In a remote forest, high in the Himalayas of central Bhutan, a male Bengal
tiger fixes his gaze on the camera. He walks a network of paths linking the
country's national parks – corridors that are key to the conservation of
this endangered subspecies but unprotected from logging and poaching.

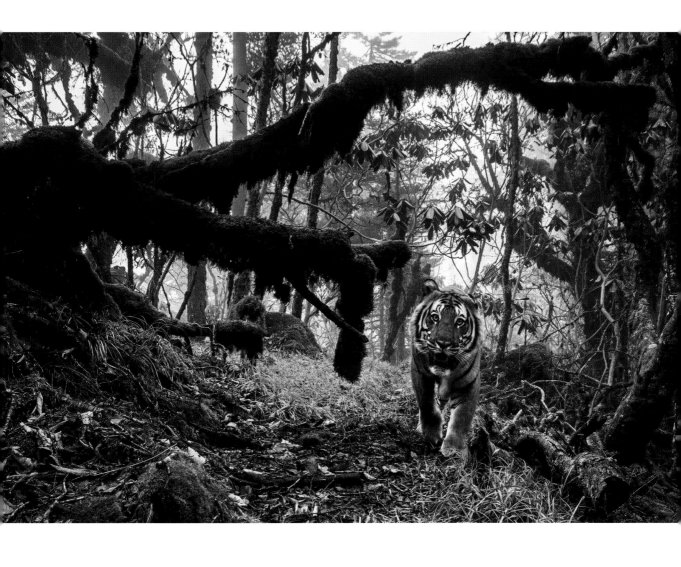

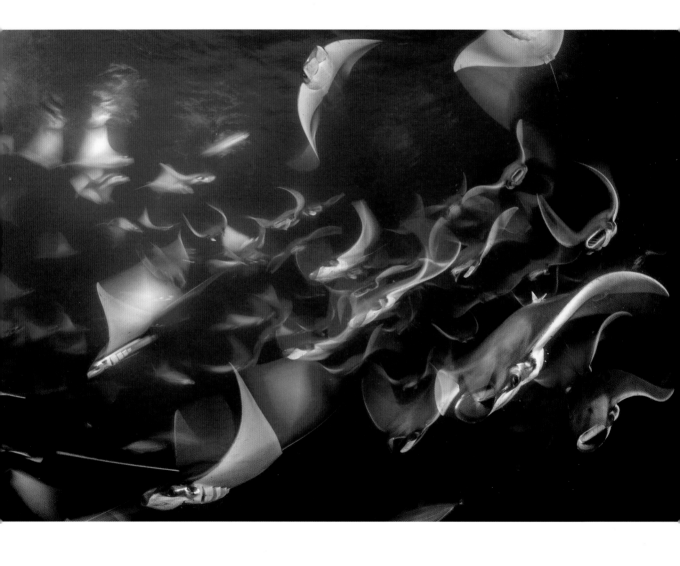

October

17 Monday

18 Tuesday

19 Wednesday

20 Thursday

21 Friday

22 Saturday	23 Sunday

Otherworldly *by Franco Banfi*
A school of Munk's devil ray were feeding on plankton at night off
the coast of Isla Espíritu Santo in Baja California, Mexico. Franco used
the underwater lights from a boat and a long exposure to create this
otherworldly image.

October

24 Monday

25 Tuesday

26 Wednesday

27 Thursday

28 Friday

29 Saturday

30 Sunday

British Summertime ends,
clocks go back

Glass-house guard *by Wayne Jones*
On the sandy seabed off the coast of Mabini in the Philippines, a yellow
pygmy goby guards its home – a discarded glass bottle. Wayne focused
on the goby's bulging blue eyes, allowing the movement of the fish to
blur the rest of its features into a haze of yellow.

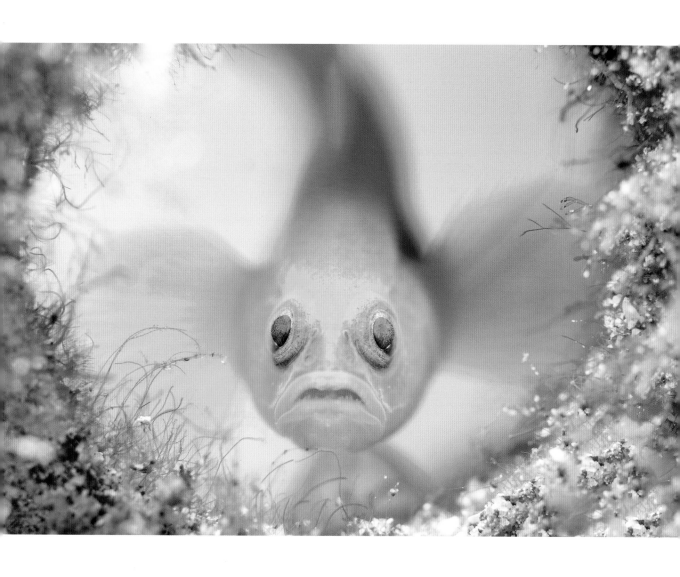

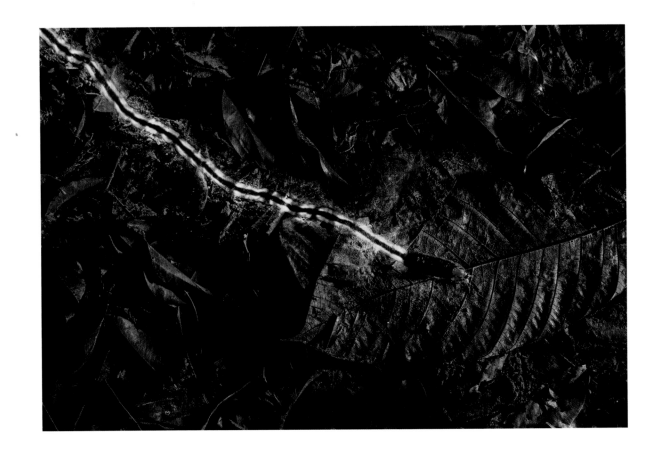

31 Monday

Hallowe'en
October holiday (Republic of Ireland)

1 Tuesday

All Saints' Day (Christian)

2 Wednesday

3 Thursday

4 Friday

5 Saturday

Guy Fawkes/Bonfire Night (UK)

6 Sunday

Trailblazer *by Christian Wappl*
The forest in Thailand's Peninsular Botanic Garden was quiet, but in the
leaf-litter, its nightlife still shone. The star of the show was a large firefly
larva, about 8 centimetres (3 inches) long, which emitted a continuous
glow from four light organs at its rear – most likely a warning to predators.

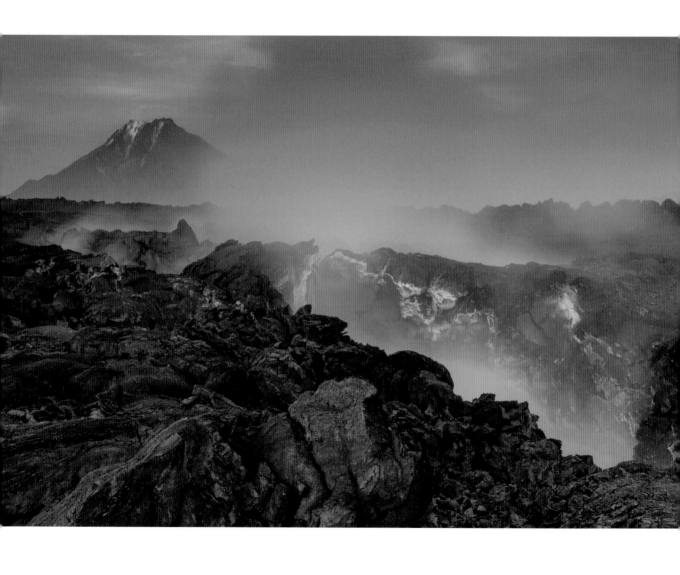

7 Monday

8 Tuesday

9 Wednesday

10 Thursday

11 Friday
<div align="right">Armistice Day</div>

12 Saturday	**13** Sunday Remembrance Sunday

Inner fire *by Denis Budkov*
A river of red-hot lava flowed beneath the crust of the Tolbachinsky
Dol lava field, on the flank of the Plosky Tolbachik volcano, Kamchatka
Peninsula in the Russian Far East. Out of a deep crevice – glowing from
the extreme heat – rose a thick plume of gas, like 'dragon's breath'.

14 Monday

15 Tuesday

16 Wednesday

17 Thursday

18 Friday

19 Saturday

20 Sunday

Dinner for two *by Justin Gilligan*
Stranded in a rockpool on the coast of New South Wales, Australia, a pair
of blue dragons feast on a by-the-wind sailor, a jellyfish-like hydrozoan.
Lighting his shot from beneath, Justin framed the elaborate forms from
above against a galaxy of reflective particles.

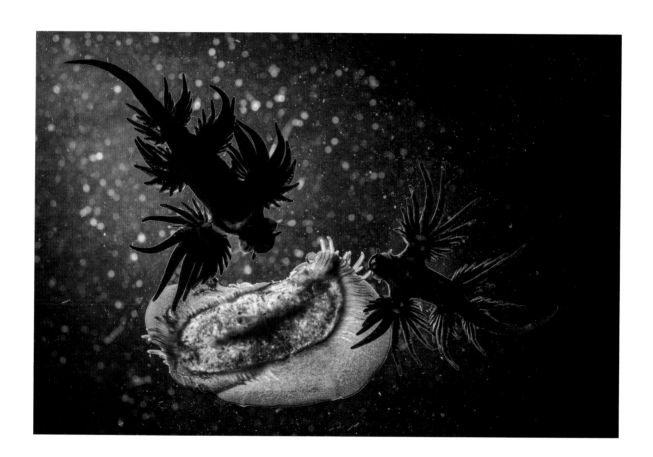

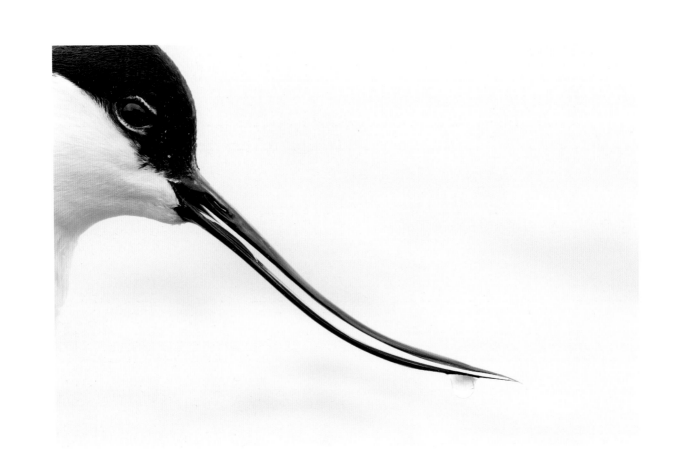

November

21 Monday

22 Tuesday

23 Wednesday

24 Thursday

25 Friday Thanksgiving (USA)

26 Saturday | 27 Sunday

Unique bill *by Rob Blanken*
The pied avocet has a unique and delicate bill, which it sweeps like a
scythe as it sifts for small invertebrates in shallow brackish water. This
stunning portrait was taken from a hide in the northern province of
Friesland in The Netherlands.

28 Monday

29 Tuesday

30 Wednesday St Andrew's Day, holiday (Scotland)

1 Thursday

2 Friday

3 Saturday	4 Sunday

Dolomites by moonlight *by Georg Kantioler*
Close to his home in the Italian South Tyrol, Georg watched the wind-
whipped clouds scud across the imposing jagged outline of the sharp
mountain peaks of the Odle massif, backlit by moonlight. With a long
exposure of 1 minute and 45 seconds, he created this spooky illusion.

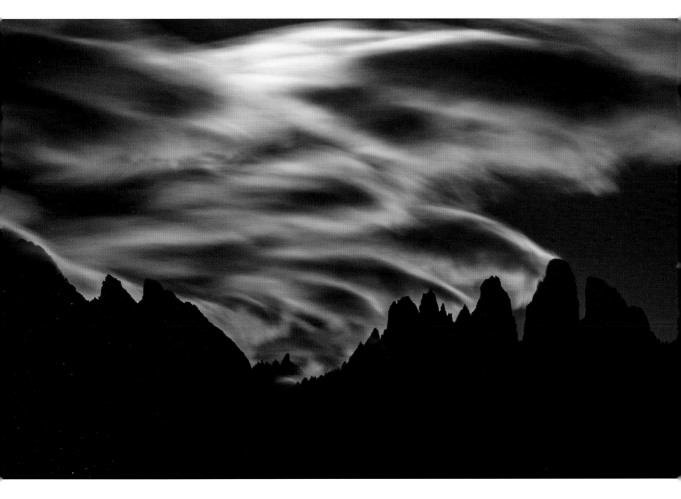

5 Monday

6 Tuesday

7 Wednesday

8 Thursday

9 Friday

10 Saturday

11 Sunday

Clam close-up *by David Barrio*
This macro-shot of an iridescent clam was taken in the Southern Red Sea,
Marsa Alam, Egypt. These clams spend their lives embedded amongst
stony corals, where they nest and grow. It took David some time to
approach the clam, fearing it would sense his movements and snap shut.

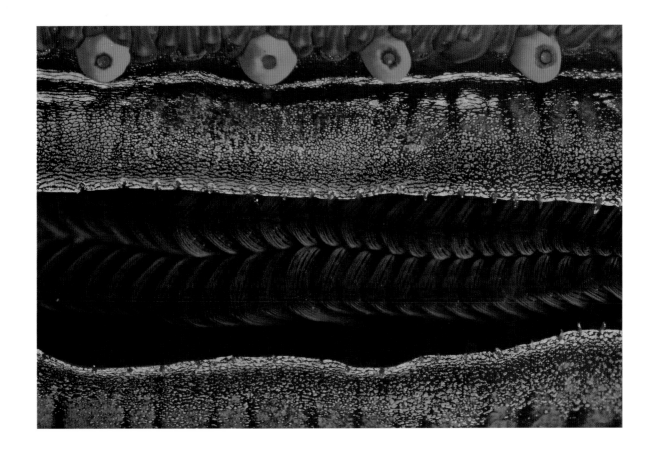

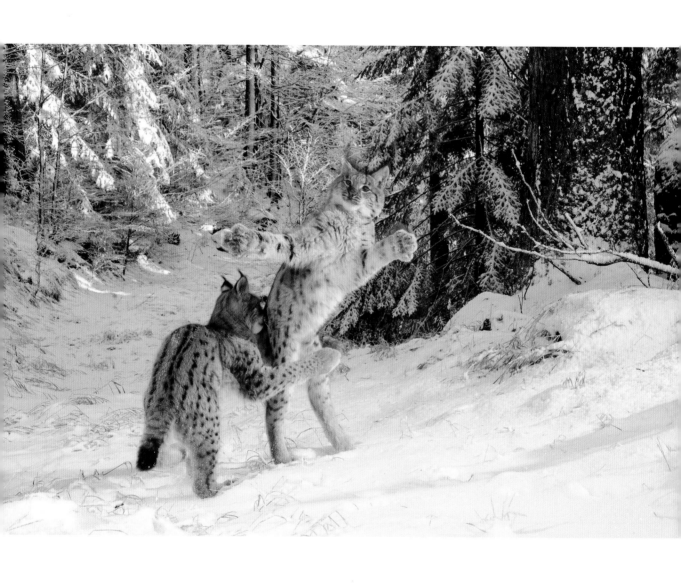

December

12 Monday

13 Tuesday

14 Wednesday

15 Thursday

16 Friday

17 Saturday

18 Sunday Hanukkah, Festival of Lights (Jewish)
begins in the evening

Kitten combat *by Julius Kramer*
It had been more than a year since Julius set up his camera trap in
Germany's Upper Bavarian Forest, and he had got just two records of
Eurasian lynx. Then his luck changed and two six-month-old kittens
turned up to play – honing their hunting skills with joyful exuberance.

December

19 Monday

20 Tuesday

21 Wednesday Winter Solstice

22 Thursday

23 Friday

24 Saturday Christmas Eve (Christian) | 25 Sunday Christmas Day (Christian)

Midnight crossing *by Vegard Lødøen*
A young male red deer crosses a river at midnight in the mountain valley
of Valldal, Norway. They are plentiful, but hunted and wary. Triggering
the sensor on Vegard's submerged camera trap, he poses. A sprinkling of
snow adds the finishing touches to this dreamy picture.

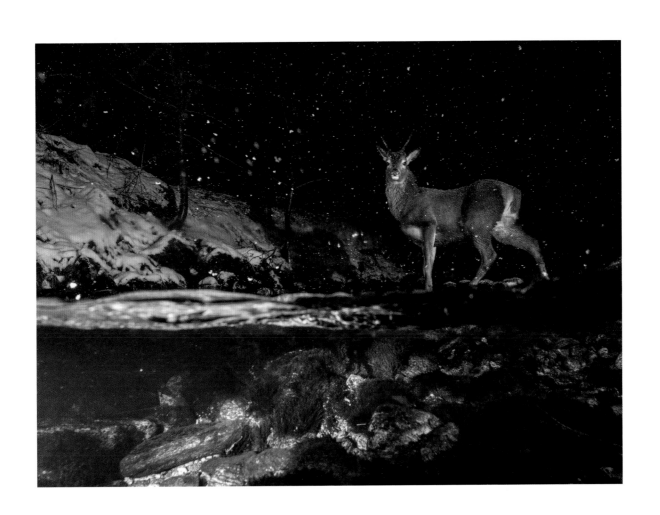

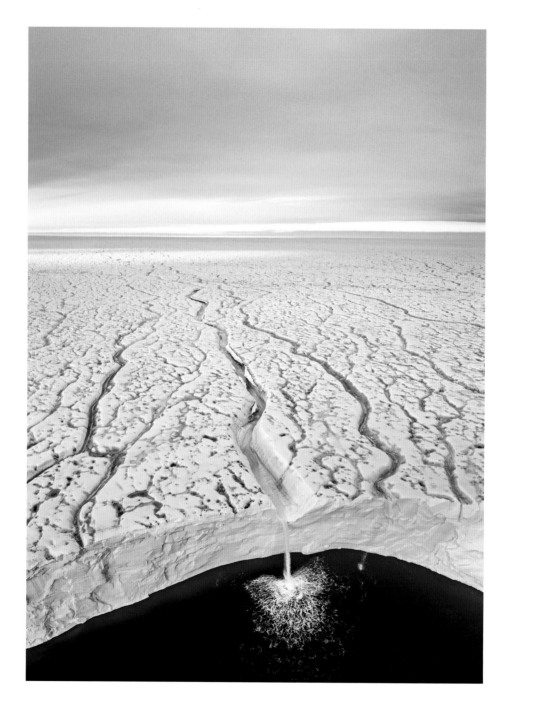

26 Monday

<div align="right">Boxing Day (Christian)
Christmas Day, holiday (Christian)
Hanukkah, Festival of Lights (Jewish)
ends in the evening</div>

27 Tuesday

<div align="right">Boxing Day, holiday (Christian)</div>

28 Wednesday

29 Thursday

30 Friday

31 Saturday

<div align="right">New Year's Eve
Hogmanay (Scotland)</div>

1 Sunday

<div align="right">New Year's Day</div>

Ice and water *by Audun Lie Dahl*
The Bråsvellbreen glacier moves southwards from one of the ice caps
covering the Svalbard Archipelago, Norway. Where it meets the sea, the
glacier wall is so high that only the waterfalls are visible, so Audun used
a drone to capture this unique perspective.

Notes

Notes

Index of photographers

Week 46
Dinner for two
Justin Gilligan
Australia
justingilligan.com
Nikon D810 + 60 mm f2.8 lens; 1/320 sec at f10; ISO 2000; Scubapro flashlight.

Week 3
A bear on the edge
Sergey Gorshkov
Russia
gorshkov-photo.com
Nikon D5 + 70–200 mm f2.8 lens at 98 mm; 1/3200 sec at f5; ISO 500.

Week 15
Bear territory
Marc Graf
Austria
sonvilla-graf.com
Canon 7D + 11–22 mm f3.5–4.5 lens; 1/25 sec at f10; ISO 250; two Nikon SB-28 flashes; Camtraptions PIR motion sensor.

Week 13
Desert relic
Jen Guyton
Germany/USA
jenguyton.com
Canon EOS 7D + Sigma 10–20 mm f4–5.6 lens at 10 mm; 1/100 sec at f22; ISO 400; Venus Laowa flash; Manfrotto tripod.

Week 36
The victor
Adam Hakim Hogg
Malaysia
adamhakim70d@gmail.com
Lumix GH3 + Canon 70–200 mm f2.8 lens + micro 4/3 adaptor; 1/1000 sec; ISO 1600.

Week 14
City fisher
Felix Heintzenberg
Germany/Sweden
felix@heintzenberg.com
Canon EOS-1D X + 100–400 mm f4.5–5.6 lens at 110 mm; 1/25 sec at f14; ISO 100; Speedlite 580EX II flash + two 540EZ flashes; tripod; Pocket Wizard Plus III transceiver; hide.

Week 43
Glass-house guard
Wayne Jones
Australia
@universal_jones
Canon EOS 5D Mark IV + 100 mm f2.8 lens + Nauticam super macro converter (SMC-1); 1/200 sec at f8; ISO 200; Nauticam housing; two Sea & Sea strobes.

Week 8
Ice-cave blues
Georg Kantioler
Italy
kantioler.it
Canon EOS 5D Mark IV + Sigma 12–24 mm f4 lens at 17 mm; 1/5 sec at f20; ISO 200; cable release; Manfrotto tripod + ballhead.

Week 48
Dolomites by moonlight
Georg Kantioler
Canon EOS 5D Mark IV + 100–400 mm f4.5–5.6 lens at 286 mm; 105 sec at f16; ISO 50; cable release; Manfrotto tripod + ballhead. cable release; Manfrotto tripod + ballhead.

Week 50
Kitten combat
Julius Kramer
Germany
fokusnatur.de
Nikon D3 + 28–80 mm f3.3–5.6 lens at 38 mm; 1/40 sec at f11; ISO 1250; two Nikon SB-28 flashes; Trailmaster trail monitor.

Week 22
Red, silver and black
Tin Man Lee
USA
tinmanlee.com
Canon 1DX Mark II + 600 mm f4 lens; 1.4x teleconverter; 1/1600 sec at f11; ISO 2000.

Week 52
Ice and water
Audun Lie Dahl
Norway
wefollowheroes.com
DJI Phantom 4 pro + 24 mm lens; 1/120 sec at f 6.3; ISO 100. Panorama of 3 images.

Week 51
Midnight crossing
Vegard Lødøen
Norway
vlfoto.no
Nikon D500 + 14–24 mm f2.8 lens at 14 mm; 1/200 sec at f10; ISO 400; two SB-600 flashes; motion sensor + Hähnel flash trigger; home-made housing.

Week 35
Fox meets fox
Matthew Maran
UK
matthewmaran.com
Canon EOS 5D Mark III + 70–200 mm f2.8 IS II USM lens; 1/500 sec at f4.0; ISO 800.

Week 33
One toy, three dogs
Bence Mate
Hungary
bencemateshides.com
Canon EOS-1DX Mark II; 200–400 mm lens (35 mm equivalent: 197.2–394.3 mm); 1/1800 sec at f4.0; 4000 ISO.

Week 29
Overview
Cameron McGeorge
New Zealand
cameronmcgeorge.co.nz
DJI Mavic Pro + 4.73 mm lens; 1/25 sec at f2.2; ISO 150.

Week 40
Delta design
Paul Mckenzie
Ireland/Hong Kong, China
wildencounters.net
Canon EOS 5D Mark IV + 24–105 mm f4 lens at 32 mm; 1/5000 sec at f4; ISO 400.

Week 37
Lounging leopard
Skye Meaker
South Africa
skyemeaker.com
Canon EOS-1D X + 500 mm f4 lens; 1/80 sec at f4; ISO 1250.

Week 4
Under the snow
Audren Morel
France
audrenmorel.piwigo.com
Nikon D7200 + Nikon 300 mm f4 lens; 1/1600 sec at f4 (-0.7e/v); ISO 500.

Week 10
Duck of dreams
Carlos Perez Naval
Spain
@carlospereznaval
Nikon D7100 + 200–400 mm f4 lens
at 400 mm; 1/320 sec at f4; ISO 1000.

Week 24
Small world
Carlos Perez Naval
Nikon D700 + 105 mm f2.8 lens; 1/60
sec at f20; ISO 1600.

Week 23
Cool cat
Isak Pretorius
South Africa
theafricanphotographer.com
Canon EOS-1D X Mark II + 600 mm f4
lens; 1/400 sec at f4; ISO 1600.

Week 6
Night snack
Audun Rikardsen
Norway
audunrikardsen.com
Canon EOS 5D Mark IV + 14 mm
f2.8 lens; 1/80 sec at f2.8; ISO 1600;
Aquatech housing.

Week 41
Tigerland
Emmanuel Rondeau
France
emmanuelrondeau.com
Canon EOS 550D + Sigma 10–20 mm
f4–5.6 lens at 16 mm; 1/20 sec
at f9; ISO 200; two Nikon SB-28
flashes; TrailMaster camera trigger +
Camtraptions wireless flash triggers.

Week 52 (2021)
Curious encounter
Cristobal Serrano
Spain
cristobalserrano.com
Canon EOS 5D Mark IV + Canon EF
8–15 mm f4L Fisheye USM lens; 1/250
sec at f8; ISO 160; Seacam housing
and flash.

Week 9
The ice pool
Cristobal Serrano
DJI Phantom 4 Pro Plus + 8.8–24 mm
f2.8–11 lens; 1/120 sec at f4.5; ISO
100.

Week 2
The extraction
Konstantin Shatenev
Russia
@konstantin_shatenev
Canon1DX + EF300 f4IS USM lens;
1/1250 sec at f13; ISO800.

Week 17
Sinuous moves
Lorenzo Shoubridge
Italy
naturephotography.it
Nikon D700 + 150 mm f2.8 lens; 1/320
sec at f4.5; ISO 400.

Week 18
Family portrait
Connor Stefanison
Canada
connorstefanison.com
Canon 1D Mark IV + Canon 500 mm
f4 IS lens; 1/200 sec at f7.1; ISO 1250;
Manfrotto monopod.

Week 39
Reflective sunset
Sri Ram Mohan Akshay Valluru
India
@the_valluri_photography
Canon EOS-1D X + 500 mm f4 lens;
1/100 sec at f4; ISO 400; beanbag.

Cover & week 1
Three kings
Wim van den Heever
South Africa
wimvandenheever.com
Nikon D810 + Nikon 24–70 mm f2.8
lens at 40 mm; 1/250 sec at f11; Nikon
SB910 flash.

Week 28
The golden couple
Marsel van Oosten
The Netherlands
squiver.com
Nikon D810 + Tamron 24–70 mm f2.8
lens at 24 mm; 1/320 sec at f8; ISO
1600; Nikon SB-910 flash.

Week 44
Trailblazer
Christian Wappl
Austria
christianwappl.com
Canon EOS 5DS + 16–35 mm f4 lens
at 35 mm; 33 sec at f5.6; ISO 1600;
Yongnuo flash; cable release; Gitzo
tripod.

Week 12
Meadow song
Fred Zacek
Estonia
zacekfoto.ee
Nikon D500 + 300 mm f4 lens + 1.4x
teleconverter; 1/640 sec at f5.6; ISO
1600.

First published by the Natural History Museum, Cromwell Road, London SW7 5BD.
© The Trustees of the Natural History Museum, London 2020. All Rights Reserved.
Photographs © the individual photographers.
Text based on original captions used in the Wildlife Photographer of the Year exhibitions.
ISBN: 978 0 565 09508 6
All rights reserved. No part of this publication may be transmitted in any form or by any
means without prior permission of the publisher.
A catalogue record for this book is available from the British Library.
Printed by Toppan Leefung Printing Ltd. China.

Every effort has been made to ensure the accuracy of listed holiday dates, however,
some may have changed after publication for official or cultural reasons.